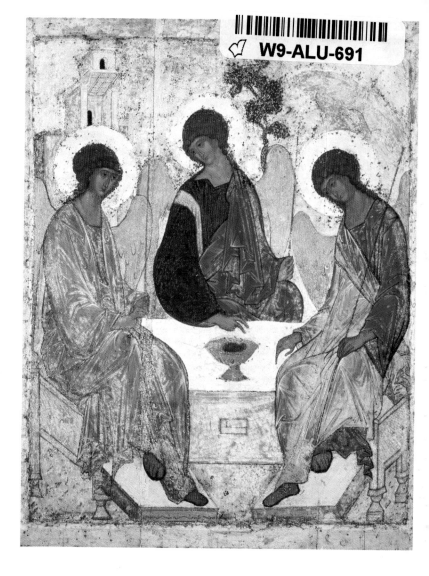

The Holy Trinity

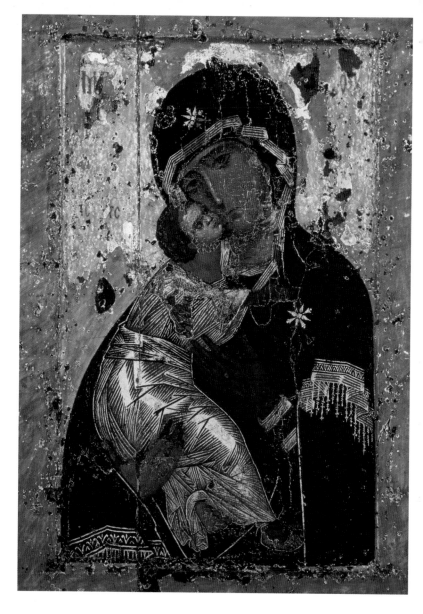

The Virgin of Vladimir

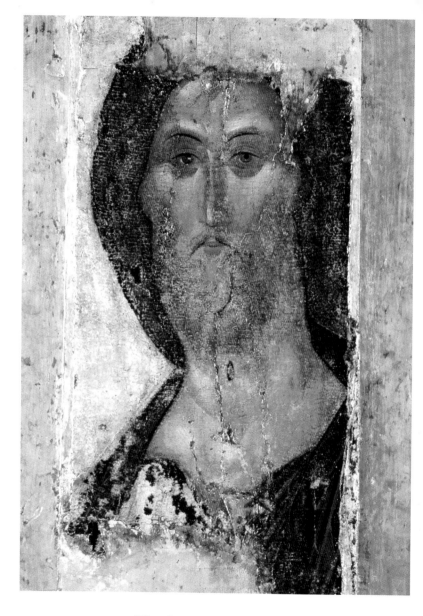

The Savior of Zvenigorod

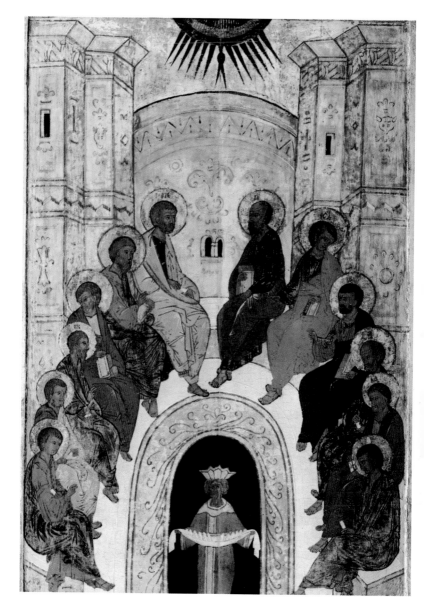

The Descent of the Holy Spirit

Behold the Beauty of the Lord

OTHER BOOKS BY
HENRI J. M. NOUWEN

published by Ave Maria Press

CAN YOU DRINK THE CUP?

THE DANCE OF LIFE
edited by Michael Andrew Ford

ETERNAL SEASONS
edited by Michael Andrew Ford

HEART SPEAKS TO HEART

IN MEMORIAM

OUT OF SOLITUDE

WITH OPEN HANDS

Learn more about Nouwen, his writing, and the work of
the Henri Nouwen Society at www.HenriNouwen.org.

Behold the Beauty of the Lord

Praying with Icons

Henri J.M. Nouwen
Foreword by Robert Lentz, O.F.M.

ave maria press AmP notre dame, indiana

First printing, February 1987

First revised edition, October 2007

123,000 copies in print

All scripture quotations are taken from *The Jerusalem Bible* (Garden City, NY: Doubleday, & Co., 1966), except the psalms on pages 34 and 78, which are taken from the Grail translation (*The Psalms: A New Translation*, Glasgow: Collins, 1966).

Founded in 1865, Ave Maria Press is a ministry of the Indiana Province of Holy Cross.

www.avemariapress.com

ISBN-10 1-59471-136-4 ISBN-13 978-1-59471-136-7

Cover design by: David Scholtes

Text design by: Ellen Voglrieder

Printed and bound in the United States of America.

To Barbara and Simone

CONTENTS

Introduction

A Gentle Invitation

Where Heart Speaks to Heart

The Circle, the Cross, and Liberation

Conclusion

Introduction

The Eyes of the Virgin

The Hands of the Virgin

FOREWORD

Many years ago, on a rainy fall day in New Orleans, I found myself face to face with Henri Nouwen at a Franciscan house of hospitality in the French Quarter. I was struck immediately by the depth of his soul, and felt waves of compassion embracing me. I feel his presence even now, twenty-five years later, though I never met Henri again in this life. Henri had seen icons I had painted. He asked me that day if I would create one for him. The icon of Christ the Bridegroom, which I went home and painted, accompanied him the rest of his life. When he first wrote this book, he asked me to review the text. Our connection was through icons: he a Latin Rite Catholic, and I Byzantine. Perhaps it is appropriate, then, that I am writing a foreword to this new edition.

Byzantine icons capture the richness of the mystical life of Eastern Christianity. After many centuries of isolation, western Christians are

slowly finding their way back to the wellsprings of Christianity in the East. They are drawn to Byzantine icons, even though they may find them strange. Knowing they are on unfamiliar soil, they wonder what the correct approach to an icon might be, how to interpret an icon correctly.

Correctly? How we Christians fear straying from the correct path! In our concern to do it right, we have forgotten how to respond spontaneously to an encounter with the Divine. We remain children, depending on someone else's approval, in that most important core of our life, the spiritual. We don't learn how to pray, only to say approved prayers. We sit at the dark edges of a richly laden banquet hall, hoping for a few crumbs that might fall our way.

This was not Henri's path. The compassion that overwhelmed me in our encounter in New Orleans came from years of feasting at tables in the divine banquet hall. As sensitive as he was, it probably took Henri years to overcome

his fears about not doing it "right." That he eventually did overcome those fears, however, is evidenced by this beautiful book.

Some of the meaning that Henri found in the four icons featured in this book is not what Byzantine Christians would find. In spite of his scholarly research, he strayed from a strict Byzantine interpretation. He followed his heart. He didn't do it "right." In this sense, *Behold the Beauty of the Lord* is not a book for academic research. On a much more profound level, however, Henri did it absolutely "right." As a western Christian, he opened his heart in prayer as he gazed upon these four icons, and found meaning which spoke directly to his own soul.

Love is the measure of all things Christian. The mind has its place, but it is with the heart that we love. "Christ flees," says St. Bonaventure, "when we try to embrace him with the intellect." Henri entered these four icons with the heart of a lover. He found God in his own way, which was actually the only authentic way he

could find God. He invites you to do the same. If you want to study Byzantine iconography, there are shelves of academic books waiting to be read. If you want to accompany a master of the spiritual life as he prays with Byzantine icons, this book is for you. Henri had a brilliant intellect, but as a lover he knew the wisdom of holy foolishness. In some ways, he simply stumbles into these four icons like a holy fool, challenging us also to see with eyes of love.

Brother Robert Lentz, O.F.M.
Iconographer

ACKNOWLEDGMENTS

In the fall of 1983 I came for the first time to Trosly, France, to visit l'Arche, a community for people with mental handicaps, founded by the Canadian Jean Vanier. If Barbara Swanekamp, Jean Vanier's assistant, had not put Rublev's icon of the Trinity on the table of the room where I was staying, this book would probably never have been written. After gazing for many weeks at the icon I felt a deep urge to write down what I had gradually learned to see.

The following year, when I returned to Trosly to make a retreat, Barbara had replaced the Trinity icon with the icon of Our Lady of Vladimir. When the retreat was over I found myself writing again.

During a third visit, a year later, my own spiritual life had become so connected with the beauty of icons that I felt drawn to write about Rublev's Christ of Zvenigorod and the icon of the Descent of the Holy Spirit. During these

months Simone Landrien offered me much support and encouragement.

The faithful friendship of Barbara and Simone has been a strong incentive in writing these reflections. In gratitude, I dedicate this book to them.

I owe a word of thanks to Roberta Reeder and Charles Busch, who directed me to the most significant literature and the most faithful reproductions. I am also deeply grateful to Elisabeth Ozolin and Robert Lentz for reading the manuscript and offering critical comments.

Most of all I want to thank Peter Weiskel and Phil Zaeder for their very competent editing of the text, and Margaret Studier and Connie Ellis for their generous secretarial assistance.

Finally, I want to say "Thank you" to all who have opened my eyes to the icons as gateways to the divine. They are the many women and men in the East and the West who have come to "behold the beauty of the Lord" (Ps 27) by praying

with icons. May this book be an encouragement to join them in this prayer.

INTRODUCTION

When my father and mother were first married, they bought a small painting by Marc Chagall. It showed a simple vase filled with flowers standing in front of a window. My parents bought the picture because they liked it, not because Chagall was famous. In fact, he was rather unknown in those days, and the painting was not expensive. They both loved that picture and spoke about it with great affection. Today, fifty-three years later, my mother is dead, and Chagall's art has become world renowned. When I think about my mother, I often see her in the living room of our family home with the flowers of Chagall close by. Her beauty has become intimately connected with the beauty of the gentle colors of the bouquet. With my heart's eye I look at the painting with the same affection as my parents did, and I feel consoled and comforted.

The flowers of Chagall came to mind as I wondered how to explain why the four icons in this book have become so important to me. Like the painting by Chagall they have imprinted themselves so deeply upon my inner life that they appear every time I need comfort and consolation. There are many times when I cannot pray, when I am too tired to read the gospels, too restless to have spiritual thoughts, too depressed to find words for God, or too exhausted to do anything. But I can still look at these images so intimately connected with the experience of love.

Acting, speaking, and even reflective thinking may at times be too demanding, but we are forever seeing. When we dream, we see. When we stare in front of us, we see. When we close our eyes to rest, we see. We see trees, houses, roads and cars, seas and mountains, animals and people, places and faces, shapes and colors. We see clearly or vaguely, but always we find something to see.

But what do we really choose to see? It makes a great difference whether we see a flower or a snake, a gentle smile or menacing teeth, a dancing couple or a hostile crowd. We do have a choice. Just as we are responsible for what we eat, so we are responsible for what we see. It is easy to become a victim of the vast array of visual stimuli surrounding us. The "powers and principalities" control many of our daily images. Posters, billboards, television, videocassettes, movies and store windows continuously assault our eyes and inscribe their images upon our memories.

Still we do not have to be passive victims of a world that wants to entertain and distract us. We can make some decisions and choices. A spiritual life in the midst of our energy-draining society requires us to take conscious steps to safeguard that inner space where we can keep our eyes fixed on the beauty of the Lord.

I offer these meditations on four Russian icons as such a step. By giving the icons long

and prayerful attention—talking about them, reading about them, but mostly just gazing at them in silence—I have gradually come to know them by heart. I see them now whether they are physically present or not. I have memorized them as I have memorized the Our Father and the Hail Mary, and I pray with them wherever I go.

For you who will read these meditations it is important to gaze at the icons with complete attention and to pray with them. Gazing is probably the best word to touch the core of Eastern spirituality. Whereas St. Benedict, who has set the tone for the spirituality of the West, calls us first of all to listen, the Byzantine fathers focus on gazing. This is especially evident in the liturgical life of the Eastern church. The words in this book come from my own gazing at these icons. They may or may not touch you. But if they help you only a little to start seeing these icons for yourself, my words will have fulfilled their purpose and may be forgotten. Then these

icons will have become yours and they can guide you by day and by night, in good times and in bad, when you feel sad and when you feel joyful. They will begin to speak of the unique way in which God has chosen to love you.

Why icons? Would it not have been better to use more accessible paintings such as those by Michelangelo, Rembrandt, or Marc Chagall? The great treasures of Western art might indeed be more attractive, but I have chosen icons because they are created for the sole purpose of offering access, through the gate of the visible, to the mystery of the invisible. Icons are painted to lead us into the inner room of prayer and bring us close to the heart of God.

In contrast to the more familiar art of the West, icons are made according to age-old rules. Their forms and colors depend not merely upon the imagination and taste of the iconographer, but are handed down from generation to generation in obedience to venerable traditions. The iconographer's first concern is not to make

himself known but to proclaim God's kingdom through his art. Icons are meant to have a place in the sacred liturgy and are thus painted in accordance with the demands of the liturgy. As does the liturgy itself, icons try to give us a glimpse of heaven.

This explains why icons are not easy to "see." They do not immediately speak to our senses. They do not excite, fascinate, stir our emotions, or stimulate our imagination. At first, they even seem somewhat rigid, lifeless, schematic, and dull. They do not reveal themselves to us at first sight. It is only gradually, after a patient, prayerful presence that they start speaking to us. And as they speak, they speak more to our inner than to our outer senses. They speak to the heart that searches for God.

It has taken me a long time to *see* the icons which I have brought together in this book, and I still wonder how much I have truly seen. It seems that always something new remains to be seen. An icon is like a window looking out upon

eternity. Behind its two dimensional surface lies the garden of God, which is beyond dimension or size. Every time I entrust myself to these images, move beyond my curious questions about their origin, history, and artistic value, and let them speak to me in their own language, they draw me into closer communion with the God of love.

The four Russian icons I have chosen: the icon of the Holy Trinity, the icon of the Virgin of Vladimir, the icon of the Savior of Zvenigorod and the icon of the Descent of the Holy Spirit, express four aspects of the mystery of our salvation. The first invites us to dwell in the house of love, the second assures us that we truly belong to God, the third unveils for us the face of the Lord and the fourth commissions us to liberate the world. Together they express the Christian understanding of our origin and destiny.

As you read these meditations, be sure to keep the icons themselves always before you; they were painted for both the glory of God

and our salvation. I pray that these four icons will imprint themselves upon your heart and strengthen the awareness of God's magnificent and loving presence in your life. May they become faithful guides on your journey and vital sources of lasting joy and peace.

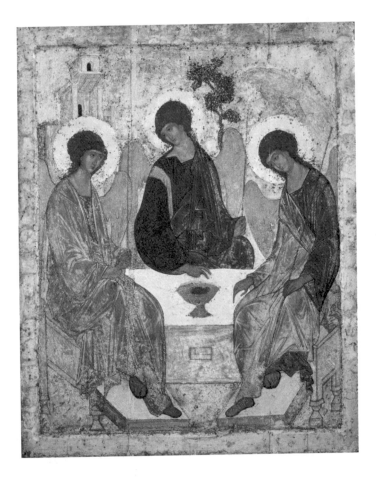

I

THE ICON OF THE HOLY TRINITY

Living in the House of Love

INTRODUCTION

How can we live in the midst of a world marked by fear, hatred, and violence, and not be destroyed by it? When Jesus prays to his Father for his disciples he responds to this question by saying,

> "I am not asking you to remove
> them from the world
> but to protect them from the evil one.
> They do not belong to the world
> any more than I belong to the world."
> (Jn 17:15–16)

To live in the world without belonging to the world summarizes the essence of the spiritual life. The spiritual life keeps us aware that our true house is not the house of fear, in which the powers of hatred and violence rule, but the house of love, where God resides.

Hardly a day passes in our lives without our experience of inner or outer fears, anxieties,

apprehensions, and preoccupations. These dark powers have pervaded every part of our world to such a degree that we can never fully escape them. Still it is possible not to belong to these powers, not to build our dwelling place among them, but to choose the house of love as our home. This choice is made not just once and for all but by living a spiritual life, praying at all times and thus breathing God's breath. Through the spiritual life we gradually move from the house of fear to the house of love.

I have never seen the house of love more beautifully expressed than in the icon of the Holy Trinity, painted by Andrew Rublev in 1425 in memory of the great Russian saint, Sergius (1313–1392). For me the contemplation of this icon has increasingly become a way to enter more deeply into the mystery of divine life while remaining fully engaged in the struggles of our hate-and-fear-filled world.[1]

A GENTLE INVITATION

Andrew Rublev painted this icon not only to share the fruits of his own meditation on the mystery of the Holy Trinity but also to offer his fellow monks a way to keep their hearts centered in God while living in the midst of political unrest. The more we look at this holy image with the eyes of faith, the more we come to realize that it is painted not as a lovely decoration for a convent church, nor as a helpful explanation of a difficult doctrine, but as a holy place to enter and stay within. As we place ourselves in front of the icon in prayer, we come to experience a gentle invitation to participate in the intimate conversation that is taking place among the three divine angels and to join them around the table. The movement from the Father toward the Son and the movement of both Son and Spirit toward the Father become a movement in which the one who prays is lifted up and held secure.

During a hard period of my life in which verbal prayer had become nearly impossible and during which mental and emotional fatigue had made me the easy victim of feelings of despair and fear, a long and quiet presence to this icon became the beginning of my healing. As I sat for long hours in front of Rublev's Trinity, I noticed how gradually my gaze became a prayer. This silent prayer slowly made my inner restlessness melt away and lifted me up into the circle of love, a circle that could not be broken by the powers of the world. Even as I moved away from the icon and became involved in the many tasks of everyday life, I felt as if I did not have to leave the holy place I had found and could dwell there whatever I did or wherever I went. I knew that the house of love I had entered has no boundaries and embraces everyone who wants to dwell there.

Through the contemplation of this icon we come to see with our inner eyes that all engagements in this world can bear fruit only when

they take place within this divine circle. The words of the psalm, "The sparrow has found its home at last. . . . Happy those who live in your house" (Ps 84:3, 4) are given new depth and new breadth; they become words revealing the possibility of being in the world without being of it. We can be involved in struggles for justice and in actions for peace. We can be part of the ambiguities of family and community life. We can study, teach, write, and hold a regular job. We can do all of this without ever having to leave the house of love. "Fear is driven out by perfect love," says Saint John in his first letter (1 Jn 4:18). Rublev's icon gives us a glimpse of the house of perfect love. Fears will always assail us from all sides, but when we remain at home in God, these worldly fears have no final power over us. Jesus said it so unambiguously:

> "In the world you will have trouble,
> but be brave:
> I have conquered the world."
> (Jn 16:33)

Where Heart Speaks to Heart

Living in the house of God, however, is not only a protection against the fearful world, but also a revelation of the inner beauty of God. Rublev's icon allows us a preview of this inexpressible beauty.

Within the circle of the Holy Trinity, all true knowledge descends into the heart. The Russian mystics describe prayer as descending with the mind into the heart and standing there in the presence of God. Prayer takes place where heart speaks to heart, that is, where the heart of God is united with the heart that prays. Thus knowing God becomes loving God, just as being known by God is being loved by God.

From within this holy circle, this house of love, the mystery of God is revealed to us. It is the mystery of the three angels who appeared at the Oak of Mamre, who ate the meal Sarah and Abraham generously offered to them and who announced the unexpected birth of Isaac

(Gn 18). It is the mystery of hospitality expressed not only in Abraham's and Sarah's welcome of the three angels, but also in God's welcome of the aged couple into the joy of the covenant through an heir.

This angelic appearance is the prefiguration of the divine mission by which God sends us his only Son to sacrifice himself for our sins, and gives us new life through the Spirit. The tree of Mamre becomes the tree of life, the house of Abraham becomes the dwelling place of God-with-us and the mountain becomes the spiritual heights of prayer and contemplation. The lamb that Abraham offered to the angels becomes the sacrificial lamb, chosen by God before the creation of the world, led to be slaughtered on Calvary and declared worthy to break the seven seals of the scroll. This sacrificial lamb forms the center of the icon. The hands of the Father, Son, and Spirit reveal in different ways its significance. The Son, in the center, points to it with two fingers, thus indicating his mission

to become the sacrificial lamb, human as well as divine, through the Incarnation. The Father, on the left, encourages the Son with a blessing gesture. And the Spirit, who holds the same staff of authority as the Father and the Son, signifies by pointing to the rectangular opening in the front of the altar that this divine sacrifice is a sacrifice for the salvation of the world.

Thus, praying with this icon leads us into the mystery of God's self-revelation. It is a mystery beyond history, yet made visible through it. It is a divine mystery, yet human too. It is a joyful, sorrowful and glorious mystery transcending all human emotions, yet not leaving any human emotion untouched.

THE CIRCLE, THE CROSS, AND LIBERATION

But what does the icon reveal to us about our vocation? Do we truly belong to this icon, or does it leave us in a distant awe of the

immense glory of God? As the mysteries of the intimate life of the Holy Trinity are unfolded to us, our eyes become more and more aware of that small rectangular opening in front beneath the chalice. We must give all our attention to that open space because it is the place to which the Spirit points and where we become included in the divine circle. As I reflect upon it, with all the iconographic knowledge I have been able to gather, I come to the realization that this rectangular space speaks about the narrow road leading to the house of God. It is the road of suffering. While its four corners remind us that it represents the created order, including all people from north, south, east, and west, its position in the altar signifies that there is room around the divine table only for those who are willing to become participants in the divine sacrifice by offering their lives as a witness to the love of God. It is the place where the relics of the martyrs are placed, the place for the

remains of those who have offered all they had to enter into the house of love.

Thus gradually a cross is becoming visible, formed by the vertical beam of the tree, the Son, the Lamb and the world, and by the horizontal beam, including the heads of the Father and the Spirit. There is indeed no circle without a cross, no life eternal without death, no gaining life without losing it, no heavenly kingdom without Calvary. Circle and cross can never be separated. The severe beauty of the three divine angels is not a beauty without suffering. On the contrary, their seemingly melancholic beauty—the Russians speak about their joyful sorrow—evokes the words of Jesus: "Can you drink the cup?" The way of Jesus is not different from the way of his disciples:

> "A servant is not greater than his master.
> If they persecuted me,
> they will persecute you too."
> (Jn 15:20)

Here we come to the hard realization that the movement from the house of fear to the house of love does not necessarily evoke love.

> "If you belonged to the world,
> the world would love you as its
> own; but because you do not belong
> to the world, . . .
> therefore the world hates you."
> (Jn 15:19)

Still, this is the only way because it is God's way, the way we can go with confidence since it leads to the joy and the peace which the world does not know. It is the way many have chosen to walk: not only Dietrich Bonhoeffer, Martin Luther King, Jr., Ita Ford, Jean Donovan and Oscar Romero, but also countless anonymous women, men, and children who during the last decades have died as witnesses to the God of love but who remain present as a source of hope to the new communities emerging in the midst of the agonizing struggle for liberation.

CONCLUSION

Saint Sergius, in whose honor and memory Rublev painted the Trinity icon, wanted to bring all of Russia together around the Name of God so that its people would conquer "the devouring hatred of the world by the contemplation of the Holy Trinity."

Fear and hatred have become no less destructive since the fourteenth century, and Rublev's icon has become no less creative in calling us to the place of love, where fear and hatred no longer can destroy us. The longer we pray with the icon and the deeper our heart is drawn toward that mysterious place where circle and cross are both present, the more fully we come to understand how to be committed to the struggle for justice and peace in the world while remaining at home in God's love.

While Jesus predicts that people will die of fear "as they await what menaces the world" (Lk 21:26), he says to his followers: "Stay awake,

41

praying at all times for the strength to survive all that is going to happen, and to stand with confidence before the Son of Man" (Lk 21:36). After I gazed for a long time at Rublev's Trinity these words spoke to me with new power. "Praying at all times" has come to mean "dwelling in the house of God all the days of our lives." "Surviving all that is going to happen" now tells me that I no longer need to be a victim of the fear, hatred, and violence that rule the world. "Standing with confidence before the Son of Man" no longer just refers to the end of time, but opens for me the possibility of living confidently, that is, with trust (the literal meaning of con-fide) in the midst of hostility and violence.

I pray that Rublev's icon will teach many how to live in the midst of a fearful, hateful, and violent world while moving always deeper into the house of love.

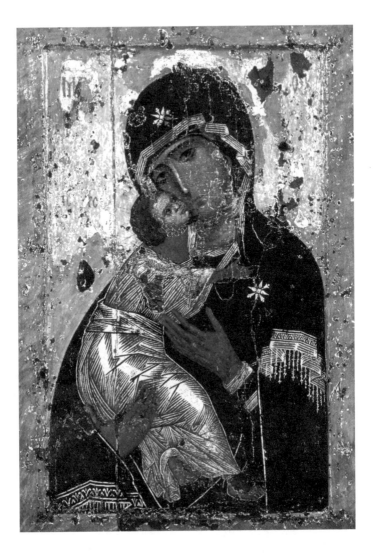

II

THE ICON OF THE VIRGIN OF VLADIMIR

Belonging to God

INTRODUCTION

To whom do we belong? This is the core question of the spiritual life. Do we belong to the world, its worries, its people and its endless chain of urgencies and emergencies, or do we belong to God and God's people? This question is not too difficult to answer. Our milieu—the persons and events we talk and agonize about, rejoice in and give thanks for—reveals to whom we truly belong. The tragedy is that for most of us this milieu is far from the divine milieu.

The icon of the Virgin of Vladimir has gradually become for me a strong yet gentle invitation to leave the compulsive and divisive milieu of the world, and to enter the liberating and uniting milieu of God. Over the years I had seen the icon in so many homes, rectories and convents that I hardly paid any attention to it. As familiar as a crucifix, the icon had lost most of its "converting power" for me. But when during a long, silent retreat a large reproduction of the Virgin

of Vladimir was placed on my table, I gradually began to discover the inner nature of the icon. As I prayed daily to the Virgin, I felt drawn into its mysterious intimacy and came to "know by heart" its urgent invitation to belong to God.

The icon, also known as "Our Lady of Tenderness," is one of the most venerated of all Russian icons. It was painted by an anonymous Greek artist at the beginning of the twelfth century. Around the year 1183 it was brought from Constantinople to Kiev, and about twenty years later from Kiev to Vladimir where it stayed until 1395. Although the icon has been in Moscow for the past six centuries, it is still called "The Virgin of Vladimir." This sacred national treasure has miraculously escaped many fires and plunderers. It has undergone several restorations, yet the faces of the mother and child are still those of the original Byzantine masterpiece.

Contemplating this icon was a profound experience for me. It was the experience of being lifted up through the intercession of the Blessed

Mother into the inner life of God. In trying to give words to this experience I shall follow the movements of my contemplation: the movement from the Virgin's eyes to her hands, from her hands to the child and from the child of the Virgin back to her eyes. These movements revealed to me the answer to the question: To whom do I belong?[2]

The Eyes of the Virgin

As a strongly psychologized contemporary person, I always seek eye contact with those I meet. It makes me feel accepted, or at least taken seriously. But as I tried to make eye contact with the Virgin of Vladimir, I realized it was impossible. At first this greatly disturbed me. I wanted her to look at me, to notice me as a unique individual, and to know me as her personal friend. But the Mother of God did not look at me. In stark contrast to most of the Renaissance

Madonnas, whose familiar look engages us in an interpersonal relationship, the Virgin of Vladimir does not enter into our familiar reality; she invites us to enter with her into the eternal life of God. Her eyes look inward and outward at once. They look inward to the heart of God and outward to the heart of the world, thus revealing the unfathomable unity between the Creator and the creation. They see the eternal in the temporal, the lasting in the passing, the divine in the human. Her eyes gaze upon the infinite spaces of the heart where joy and sorrow are no longer contrasting emotions, but are transcended in spiritual unity.

The meaning of Mary's gaze is further accentuated by the bright stars on her forehead and shoulders (only two stars are visible; one is covered by the child). They not only indicate her virginity before, during, and after the birth of Jesus, but also speak of a divine presence that permeates part of her being. She is completely open to the divine Spirit, making her innermost

being completely attentive to the creative power of God. Thus being mother and being virgin are no longer mutually exclusive. On the contrary, they bring each other to completion. Mary's motherhood completes her virginity, and her virginity completes her motherhood. That is why she carries in Greek the highest title that a human being has ever received: Theotokos, "The Bearer of God."

Praying to the Virgin of Vladimir, we learn that although she is not looking at us, she is truly seeing us. She sees us with the same eyes she sees Jesus. They are the eyes which saw her Lord before she conceived him, contemplated the Word before it became flesh in her and sensed God within before she heard the angel's message. With these eyes the Virgin sees the child. Her gaze is not that of a proud mother of an exceptional baby; she sees him with the faithful eyes of the Mother of God. Before seeing him with the eyes of her body, she saw him with the eyes of faith. That is why the Sacred

Liturgy continues to praise Mary as the one who conceived God in her heart before she conceived God in her body.

As Mary sees Jesus, so she sees those who pray to her: not as interesting human beings worthy of her attention, but as people called away from the darkness of sin into the light of faith, called to become daughters and sons of God. It is hard for us to relinquish our worldly identity as noteworthy people and accept our spiritual identity as children of God. We so much want to be looked at that we are ill prepared to be truly seen. But the eyes of the Virgin invite us to let go of our old ways of belonging and accept the good news that we truly belong to God.

THE HANDS OF THE VIRGIN

The Virgin's hands were the second aspect of the icon to become significant for me. It is

impossible to pray long with the icon without being drawn to her hands.

One hand supports the child while the other remains free in an open gesture of invitation. At first I thought the Virgin pointed to Jesus with her open hand. I now realize that the word "point" misrepresents the true meaning of her gesture. She is not simply asking attention for her Son, nor is she directing us to him. That would be too external, manipulative, and controlling. I have slowly come to see the Virgin's gesture as a gentle invitation to move closer to Jesus and discover in that movement the God to whom we belong.

Although it appears that the Virgin occupies the center place, prayerful attention reveals that her presence is totally and exclusively for the child. Mary is the mother of Jesus. Her whole being is for Jesus. Her hand does not teach, or explain, or plead. Her hand simply offers the child as the Savior of the world to all who are open to seeing Jesus with the eyes of faith.

The hand of Mary which occupies the heart of the icon is indescribably beautiful. In its centrality it summarizes the entire icon. It makes the whole image into an expression of Mary's song: "My soul proclaims the greatness of the Lord and my spirit exults in God my savior" (Lk 1:46) and gathers everything into an invitation to worship. It says: "Praise Jesus, thank Jesus, glorify Jesus, ask from Jesus, plead with Jesus, and always, always pray to Jesus." But it says all of this in the way a mother speaks to her children, not forcing them, but creating a space for them where they can find in themselves the desire for this unceasing worship.

The Virgin's eyes are not curious, investigating or even understanding, but eyes which reveal to us our true selves. Likewise her hands are not grasping, demanding, or directing, but hands which open a space for us to approach Jesus without fear.

When we pray before the icon, the guiding hand of Mary increases in importance. She

keeps moving us closer to Jesus, as if saying: "I am only here to lead you to Jesus." Mary wants us to let go of our fears and to trust—as she did—that "the promises of the Lord will be fulfilled" (Lk 1:45). As our attention moves from her eyes to her hands, we slowly recognize her profound patience. The word "patience" comes from the Latin *pati* which means to suffer. Just as the body of the risen Lord still carries the wounds of his suffering, so too is the glorified Mother of God a woman whose heart has been pierced by sorrow. She knows what it means to be poor, oppressed, a refugee, to be uncertain and confused about the future, to be kept at a distance, to stand under the cross, and to be the bearer of thoughts and feelings that cannot be shared with anyone. These sufferings linger in the gaze of her eyes and the gesture of her hands, not as frightening pain but as glorified signs of her patience.

Therefore, she is mother not only to her crucified Son, but to all women and men who

suffer in this world. She invites us, suffering people, to come to Jesus. She does not push us with an impatient gesture, but simply invites us as someone who fully knows our fears, hesitations, agonies, suspicions, and insecurities. She is the patient mother who waits for the right time to receive our "Yes." But her patience is strong, unwavering, and persevering. Her hand is always there at the heart of the mystery of the Incarnation, inviting us to come to Jesus who is the way to the house of God where we truly belong.

THE CHILD OF THE VIRGIN

Finally we can see the child. The Virgin's eyes and hands derive their profound significance from the child. While it may appear at first that the child is secondary, a prayerful viewing of the icon reveals that the child gives meaning to all that surrounds him. It is a moving experience

to have the child, who is initially dwarfed by Mary, emerge not only as the Lord of his own mother, but also as the Lord of all people and all that exists. I continue to be amazed at how the child, with his luminous face and golden mantle, could remain "hidden" for so long within the curving lines of the Virgin. Now I can hardly look at the icon without seeing the child as the older, wiser, and stronger one. Now the mother has become the one who introduces the Holy One to us and remains at a reverent distance.

It is easy to see that the child is not an infant. He is a wise man dressed in adult clothes. Moreover, the luminous face and golden tunic indicate that this wise man is truly the Word of God, full of majesty and splendor. He is the Word made flesh, the Lord of all ages, the source of all wisdom, the Alpha and Omega of creation, the Glory of God. All is light within and around the child. In the child there is no darkness. He is, in the words of the Council of

Nicea, "God from God, Light from Light, true God from true God."

Contemplating the child of the Virgin of Vladimir is like discovering a light that was always there but could not be seen because of previous blindness. Look at the face of the child! A splendid light falls from the right side of the icon, gently touching the nose of the Virgin and illuminating the face of the child. But light also comes from within. It is an inner glow that shines outward and deepens the intimacy between mother and child already expressed by the tender embrace. The light illumines and gives warmth. There is no sudden, intrusive flash, but the gradual appearance of a tender and radiant intimacy. This light-giving intimacy has not only made the icon a masterpiece in the history of art, but more importantly has drawn countless people into prayerful communion with their Lord. Faithful people from all over the world for nine centuries have come to this

sacred image to be consoled and comforted by its life-giving tenderness.

But there is much more! The divine child is giving himself completely to the Virgin. His arm holds her in an affectionate embrace, his eyes are fixed on hers with complete attentiveness, and his mouth is close to hers, offering her his divine breath. How close to the mystery of the Incarnation is this vision of God's total, unrestricted care for humanity! This sacred image reverberates with the prayer of Jesus to his Father for his disciples:

> "When the Paraclete comes,
> whom I shall send to you
> from the Father,
> the Spirit of truth who issues
> from the Father,
> he will be my witness."
> (Jn 15:26)

Jesus presents all his divine wisdom to the Mother of humanity. All he has received he

gives, all he has seen he reveals, all he has heard he speaks, all he is, he offers. It also reverberates with Jesus' promise:

> "If you ask for anything in my name,
> I will do it."
> (Jn 14:14)

Yet Jesus not only gives everything, he also receives everything. He not only says everything he has heard, he also hears everything that is said to him. He not only reveals everything he has seen, he also illumines everything that is shown to him. Nothing that comes to him from the Virgin escapes his divine attention. Everything she shows him is received, heard, and understood. Hence the Virgin is the spokesperson of humanity, the mother who intercedes for her children whatever their sorrows may be.

The tender embrace of mother and child is far from a sentimental event. It is the portrayal of the mysterious interchange between God and

humanity made possible by the Incarnation of the Word.

The deep and lasting quality of this interchange becomes visible in the heavy neck of the child. The child's neck is painted so large because it represents the Holy Spirit. Spirit means "breath." The Holy Spirit is the breath of God. It is this divine breath which Jesus offers to humanity:

> "It is for your own good
> that I am going
> because unless I go
> the Paraclete [the Spirit]
> will not come to you;
> but if I do go,
> I will send him to you."
> (Jn 16:7)

Jesus not only offers his light to humanity; he offers his breath, his innermost life, so that we may truly belong to him as brothers and

sisters and as sons and daughters of his heavenly Father.

The eyes of the Virgin drew our attention to her hands, her hands drew our attention to the child and the child leads us back to her who speaks to her Son in the name of all humanity.

CONCLUSION

I have stressed that through prayerful attention we come to see that the child is the one to whom we are asked to go, and that the child offers us—represented by the Virgin—the gift of his own breath, which is the spiritual life.

But what about the Father, the one who sent the Son and whose love for the son is the Holy Spirit? The Father is not absent! On the contrary, he is fully present, omnipresent in fact. We hardly notice his presence unless we dare to see the image as a whole. When we view it from a distance, we see that the Virgin and child

are painted in the form of a triangle placed in a rectangular frame. The rectangular frame represents the world, loved by God but held captive by sin and the powers of evil. The triangle, within which the mystery of the Incarnation is expressed, shows the redemptive presence of the triune God: Father, Son, and Holy Spirit. Although the Father is not directly visible, the geometric form of the icon reveals the Father as the divine iconographer of our redemption.

Thus "The Virgin of Vladimir" is the iconographic articulation of Jesus' words to Nicodemus:

> "God loved the world so much
> that he gave his only Son,
> so that everyone who believes in him
> may not be lost
> but may have eternal life."
> (Jn 3:16)

What else is eternal life than to be lifted up into the house of God and made a participant in

the intimate communion among the Father, the Son, and the Holy Spirit? This is what belonging to God truly means. To this belonging Our Lady of Vladimir invites us.

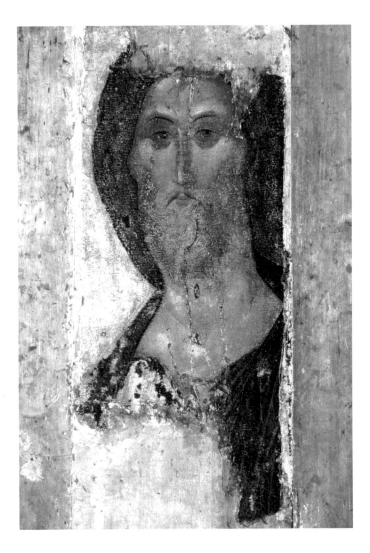

III

THE ICON OF THE SAVIOR OF ZVENIGOROD

Seeing Christ

INTRODUCTION

To see Christ is to see God and all of humanity. This mystery has evoked in me a burning desire to see the face of Jesus. Countless images have been created over the centuries to portray the face of Jesus. Some have helped me to see his face; others have not. But when I saw Andrew Rublev's icon of Christ, I saw what I had never seen before and felt what I had never felt before. I knew immediately that my eyes had been blessed in a very special way.

Andrew Rublev painted his icon of Christ at the beginning of the fifteenth century as part of a tier of icons he made for a church in the Russian city of Zvenigorod. Hence, the icon is often called the "Savior of Zvenigorod." From the original tier, only three panels are left: those depicting Michael the Archangel, Paul the Apostle, and Christ the Savior. This last panel has brought me closer than any work of art to

"seeing Christ." For this reason, I have long felt a strong desire to write about this icon.

Seeing the Christ of Rublev is an event that takes place over a long period of time and requires increasing, prayerful attentiveness. Even after months of looking at the Savior of Zvenigorod, I still cannot say that I have fully *seen* it. It seems that the longer I contemplate the icon the more it opens itself to me, always revealing something new. I have seen in this icon a damaged image, a most tender human face, and eyes that penetrate the heart of God as well as every human heart. In this meditation, I will try to describe these different levels of seeing, while acknowledging that in the presence of this holy face I am still blind.[3]

SEEING A DAMAGED IMAGE

My first impression of Rublev's icon of the Savior was that it was severely damaged. The

face of Christ is the only face left on the central panel of the tier, a panel which also once contained the faces of the Virgin Mary and John the Baptist. And before I was able to see clearly the beauty of the Savior's face and his penetrating eyes, I was preoccupied with the fact that the face was injured. A large part of the hair and small parts of the forehead are invisible, and the paint of the chin, neck, and chest is cracked. Dark streaks fall from the lower lip to the dark tunic, and the mantle covering the shoulders and the tunic has been damaged in several places. The bottom-left section of the icon is completely discolored.

When I first saw the icon, I had the distinct sense that the face of Christ appears in the midst of great chaos. A sad but still very beautiful face looks at us through the ruins of our world. Maybe this is the reason the face has haunted me for so long. Does it voice a complaint, a rebuke, or simply the question: "O what have you done to the work of my hands?"

This largely destroyed icon was found in a barn in 1918 near the Cathedral of the Assumption in Zvenigorod. The icons of the Archangel Michael and St. Paul were found with it. The Russian art historian and painter Vladimir Desyatnikov tells us how it was found:

> It was found by the restorer Vasili Kirikov by accident. As he turned over the top of one of the steps leading into the barn, he gasped with amazement at what he saw. Staring up at him was the face of the Savior painted by Andrei Rublev. . . . To this day, The Savior found in Zvenigorod is called "The Peacemaker" in Russian art. It is hard to find a more suitable epithet—for almost six centuries the Savior with a Russian face and kind, intelligent eyes expressing deep thought has been looking out on generations.[4]

As I look at the large, wooden panel on which only the face of Christ remains, I can quite well imagine how deeply Vasili Kirikov must have been moved when he first saw the face of Christ staring up at him in the barn. To me, this holy face expresses the depth of God's immense compassion in the midst of our increasingly violent world. Through long centuries of destruction and war, the face of the incarnate Word has spoken of God's mercy, reminded us of the image in which we were created, and called us to conversion. Indeed, it is the face of the Peacemaker.

The history of this icon, a history of loss and rediscovery, holds both a warning and a reassurance. Christ warns us against our destructiveness, while at the same time expressing that God's love is stronger, much stronger than our own inclination to destroy what has been so beautifully made. It seems to voice a rebuke: "If you had only recognized . . . the way to peace" (Lk 19:42), but also an invitation:

"Come to me, all you who labor and
are overburdened, and I will give
you rest. Shoulder my yoke and
learn from me, for I am gentle and
humble in heart."
(Mt 11:28)

Seeing a Most Tender Human Face

As I became more familiar with Rublev's
Christ, the image of the Savior began to domi-
nate its ruined surroundings. What was de-
stroyed gradually occupied my mind less than
what was there to be seen: the splendid figure
of Jesus, painted with a gentle yet severe beauty
I have seen nowhere else on earth.

One of the more remarkable qualities of
this Christ icon is that the iconographer has
portrayed a slight movement. The shoulders
and upper chest are painted at a three quarters
angle, while the face, eyes, nose, and lips are

set fully facing us. Thus we see Jesus turning toward us. The longer we pray before the icon the more deeply we will feel this movement. It seems as if Jesus is moving forward but then notices us, turns toward us, and looks us directly in the face.

I am reminded of the encounter between Jesus and Peter after Peter's denials: "The Lord turned and looked straight at Peter, and Peter remembered what the Lord had said to him" (Lk 22:61). Like Peter, we need to be reminded of our self-confident promises, our failure to keep them, our lack of faithfulness, and our powerlessness when we are on our own. But like Peter, we are also reminded of a love that does not leave us, a compassion that has no limits, and a forgiveness which is always offered to us again. When Peter felt the eyes of Jesus penetrating his innermost being and saw at once his own weakness and Jesus' love, "he went outside and wept bitterly" (Lk 22:62). As we look at Rublev's Savior we can better understand Peter's tears. We

feel them in ourselves. They are tears of both repentance and gratitude for so much love.

Though Rublev's icon is of such original beauty that it cannot be compared with any other, it is deeply rooted in an age-old way of painting the face of Christ. Rublev's icon is as traditional as it is original. The full hair of Christ, his high forehead, his large, open eyes, his long nose, his small mouth with moustache, his round beard, his elongated face and heavy neck are not painted after any human model, nor are they the result of Rublev's own invention. He painted the Savior in holy obedience to a highly prescribed way of painting handed down by Greek and Russian iconographers from generation to generation.

The colors are of inexpressible beauty. Various art historians have tried to describe them. M. Alpatov writes:

> There is a resonance of colors, a
> harmony of cold blue tones with soft

rose and gold. . . . Barely highlighted
as in fresco painting, the colors are
distinguished by great brightness.
They harmonize with the tenderness
reflected in the face.[5]

And V. N. Lazarev adds:

The unparalleled beauty of the cool,
light colors of the . . . icon holds the
spectator in thrall. The azure, pink,
blue, muted violet and cherry tones
are so perfectly blended against the
gold background that they frequently
arouse musical associations. Rublev
used color as a means for revealing
spiritual qualities.[6]
The most striking color is the rich
blue of the mantle that covers the
shoulders of the Savior. In many
Greek and Russian icons Christ is
painted with a red tunic covered by
a blue mantle, whereas the Virgin
is painted with a red veil draped

over a blue tunic. Red is the color
of divinity, blue of humanity. Christ
the divine Word is clothed by God
with humanity. The Virgin, created
human, is over-shadowed by the
divinity of the Spirit.

Rublev follows this color scheme, but his
blue is starker and brighter than that in any
Christ image I know. Indeed, it seems that
Rublev wanted to accentuate the humanity of
Christ more than his predecessors had done.
The bright azure mantle makes us see more
clearly the lovely human face of God. It is en-
dowed with

an irresistible charm, a gentleness in
which there is no trace of Byzantine
severity. Rublev's profoundly
human Christ recalls the famous
statue of Christ in the tympanum
of the "Royal Door" of the Chartres
Cathedral. Both the Russian and the
early Gothic master humanize Christ

to such an extent that we lose sight
of the abstract, cult-like element in
the representation.[7]

Rublev's Christ has "a rare combination of
elegance and strength, tenderness and firmness
which expresses above all the charm of human
virtue."[8]

Most icons of Jesus, Greek as well as Russian, inspire great awe by their stern and severe
expressions. Some are even frightening! They
stress the splendor of God's majesty to such
a degree that the only appropriate response,
it seems, is to prostrate oneself in humble acknowledgment of one's total unworthiness
in the presence of God. But when we look at
Rublev's Christ something new takes place. It
seems as if Jesus comes down from his throne,
touches our shoulders and invites us to stand
up and look at him. His handsome, open
face evokes love, not fear. He is Emmanuel,

God-with-us. He says: "Yes, it is I indeed. Touch me and see for yourselves" (Lk 24:39). He even asks us for food, so that we will know that he is not a ghost but a person with whom we can speak and eat (see Luke 24:36–43). We still feel awe, but it is an awe enriched by joy, the same joy that filled the disciples when they recognized their risen Lord (see Luke 24:41).

SEEING EYES THAT PENETRATE BOTH THE HEART OF GOD AND EVERY HUMAN HEART

But what finally makes seeing Rublev's icon such a profound spiritual experience are the eyes of the Savior. Their gaze is so mysterious and deep that any word which tries to describe them is inadequate. While the eyes of Our Lady of Vladimir look beyond us in order to lead us into the mystery of her own contemplation, the Christ of Rublev looks directly at us and confronts us with his penetrating eyes. They are

large, open eyes accentuated by big brows and deep, round shadows. They are not severe or judgmental but they see all that is. They form the true center of the icon. One could say "Jesus is all eyes." His penetrating look brings to mind the words of the psalmist:

> O Lord, you search me and
> you know me
> you know my resting and my rising,
> you discern my purpose from afar.
> You mark when I walk or lie down,
> all my ways lie open to you. . . .
> O where can I go from your spirit,
> or where can I flee from your face?
> (Ps 139:1–3, 7)

These words do not speak of a fear-inspiring omnipresence, but of the loving care of someone who looks after us at all times and in all places. The eyes of Rublev's Jesus are neither sentimental nor judgmental, neither pious nor harsh, neither sweet nor severe. They are the

eyes of God, who sees us in our most hidden places and loves us with a divine mercy. N. A. Dyomina writes:

> The look in Christ's face is the most significant feature in this new conception [of Rublev]. The gaze is directed upon the spectators with concentrated attention and a desire to look into their hearts and understand them. The brows are slightly lifted, but there is no impression of tension or grief: the gaze is clear and benevolent. We see before us a strong personality with sufficient moral and physical energy to give aid to those in need of it.[9]

And Alpatov adds: "Before the icon of the Savior [of Rublev] we feel face to face with him, we look directly into his eyes and feel a closeness to him."[10]

This face-to-face experience leads us to the heart of the great mystery of the Incarnation. We can see God and live! As we try to fix our eyes on the eyes of Jesus we know that we are seeing the eyes of God. What greater desire is there in the human heart than to see God? With the apostle Philip our hearts cry out: "Lord, let us see the Father and then we shall be satisfied." And the Lord answers:

> "To have seen me is to have seen
> the Father . . .
> Do you not believe
> that I am in the Father
> and the Father is in me?"
> (Jn 14:8–10)

Jesus is the full revelation of God, "the image of the unseen God" (Col 1:15). Looking into the eyes of Jesus is the fulfillment of our deepest aspiration.

It is hard to grasp this mystery, but we must try to sense how the eyes of the Word incarnate

truly embrace in their gaze all there is to be seen. The eyes of Rublev's Christ are the eyes of the Son of Man and the Son of God described in the book of Revelation. They are like flames of fire which penetrate the mystery of the divine. They are the eyes of one whose face is like the sun shining with all its force, and who is known by the name: Word of God (see Revelation 1:14, 2:18, 1:16, 19:12–13). They are the eyes of the one who is "Light from Light, true God from true God, begotten, not made, one in being with the Father . . . through whom all things were made" (Nicene Creed). He is indeed the light in whom all is created. He is the light of the first day when God spoke the light, divided it from the darkness, and saw that it was good (Gn 1:3). He is also the light of the new day shining in the dark, a light that darkness could not overpower (Jn 1:5). He is the true light that enlightens all people (Jn 1:9). It is awesome to look into the eyes of the only one who truly sees the light, and whose seeing is not different from his being.

But the eyes of Christ which see the splendor of God's light are the same eyes which have seen the lowliness of God's people. The same eyes that penetrate God's eternal mystery have also seen into the innermost being of men and women, who are created in God's image. They saw Simon, Andrew, James, Philip, Nathaniel, and Levi and called them to discipleship. They saw Mary of Magdala, the widow of Nairn, the lame, the lepers, and the hungry crowd and offered them healing and new life. They saw the sadness of the rich young ruler, the fear of the disciples on the lake, the loneliness of his own mother under the cross, and the sorrow of the women at the tomb. They saw the fruitless fig tree, the desecrated temple, and the faithless city of Jerusalem. They also saw faith: the faith of the men who lowered their paralyzed friend through the roof, the faith of the Canaanite woman who asked for the scraps that fell from the master's table, the faith of the centurion whose servant was paralyzed and in great pain,

the faith of the blind Bartimaeus shouting for pity, and the faith of the woman with a hemorrhage who touched the fringe of his cloak.

The one who sees unceasingly the limitless goodness of God came to the world, saw it broken to pieces by human sin and was moved to compassion. The same eyes which see into the heart of God saw the suffering hearts of God's people and wept (see John 11:36). These eyes, which burn like flames of fire penetrating God's own interiority, also hold oceans of tears for the human sorrow of all times and all places. That is the secret of the eyes of Andrew Rublev's Christ.

CONCLUSION

Seeing the Christ of Rublev is a profound event. Through the ruins of our world, we see the luminous face of Jesus, a face that no violence, destruction, or war can finally destroy. We see

his tender humanity asking us to lay aside our fears and approach him with confidence and love. We see his eyes, eyes that penetrate not only God's own interiority, but also the vastness of human suffering throughout all history. Thus, seeing Christ leads us to the heart of God as well as to the heart of all that is human. It is a sacred event in which contemplation and compassion are one, and in which we are prepared for an eternal life of seeing.

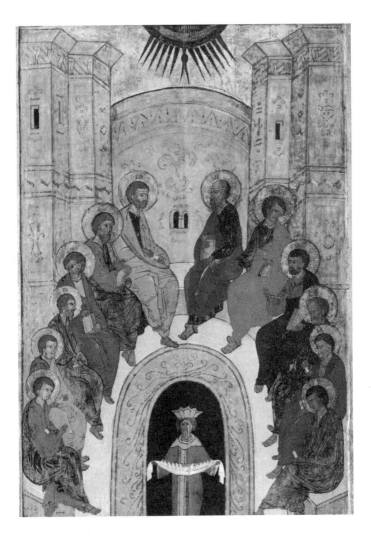

IV

THE ICON OF THE DESCENT
OF THE HOLY SPIRIT

Liberating the World

Introduction

Being a Christian is not a solitary affair. Nevertheless, we often think about the spiritual life in highly individualistic terms. We are trained to have our own ideas, speak our own minds, and follow our own ways. European and American education places so much emphasis on the development of an independent personality that we have come to view other people more as potential advisors, guides, and friends on the road to self-fulfillment than as fellow members of a community of faith.

In the intimacy of my relationship with God I still find myself thinking more about my faith, my hope, and my love than about our faith, our hope, and our love. I worry about *my* individual prayer life, I speculate about *my* future as an educated man, and I reflect on how much good *I* have done or will do for others. In all of this, it is my individual spiritual life that receives most of the attention.

"The Descent of the Holy Spirit," a Russian icon painted toward the end of the fifteenth century, has reminded me forcefully that a life in the Spirit is in essence a life in community. Although I have always known this intellectually, a long and deep encounter with this Pentecost icon from the Russian Novgorod School has gradually allowed this knowledge of the head to become a knowledge of the heart.

That God reveals the fullness of divine love first of all in community, and that the proclamation of the good news finds its main source there has radical consequences for our lives. Because now the question is no longer: How can I best develop my spiritual life and share it with others? but Where do we find the community of faith to which the Spirit of God descends and from which God's message of hope and love can be brought as a light into the world? Once this question becomes our main concern we can no longer separate the spiritual life from life in community, belonging to God from belonging

to each other and seeing Christ from seeing one another in him.

As I spent more time with this Pentecost icon, I gradually saw many new aspects of the spiritual life that other icons had not revealed to me. First, I saw how God is revealed to us at Pentecost as the God within. Then I perceived how this God within creates a new community of faith in which unity and diversity deepen each other. Finally, I discovered how this community of faith forms a vital center from which the liberation of the world can proceed. I will now show in more detail how these three aspects of the spiritual life are expressed in "The Descent of the Holy Spirit."[11]

THE GOD-WITHIN

What first strikes me about this icon is its quietude. The twelve apostles and evangelists, sitting with great calm in a semi-oval, radiate

order, peace, and solemnity. Their harmonious presence reinforces the symmetry and equilibrium of the whole icon.

This quietude stands in stark contrast to the Pentecost story itself. There (Acts 2:1–13) we read about a sudden sound from heaven, a violent wind, tongues of fire, words spoken in different languages, bewilderment, amazement, and about the sarcastic remark, "too much wine." The icon shows nothing of this: no sounds, no words, no speaking disciples, no excited crowd, no skeptical bystanders, not even tongues, but only twelve short rays descending from a part of a circle that represents heaven. What we see is complete tranquility, harmony, and order.

Has the iconographer forgotten what really took place? No, he has chosen to paint the deepest meaning of Pentecost. He wants to express the inner event. Like most great icons, "The Descent of the Holy Spirit" is less an illustration of a biblical narrative than a presentation of a theological truth. The truth revealed by this icon is

that God completes the revelation of the divine inner life by giving us the divine breath, so that God can truly become for us "God-within."

At first, in the story of the Exodus, God is revealed as a God-for-us, guiding us out of our slavery with a pillar of cloud by day, and with a pillar of fire by night (Ex 13:21). Later, in the story of Jesus of Nazareth, God is revealed as a God-with-us (Mt 1:24), accompanying us in solidarity and compassion. Finally in the story of Pentecost, God is revealed as a God-within-us, who enables us to breathe the divine life ourselves. Thus, Pentecost completes the mystery of God's revelation as Father, Son and Holy Spirit, and invites us to become fully part of the inner life of God. By becoming not only a God-for-us and a God-with-us, but also a God-within-us, God offers us the full knowledge of the divine life according to the promise of Jesus:

> "The Holy Spirit,
> whom the Father will send

> in my name,
> will teach you everything."
> (Jn 14:26)

The Pentecost icon draws us into the heart of the mystery of God's self-revelation. The way the apostles and evangelists are gathered together manifests the presence of the God-within. The open space portrayed between the central figures of Peter and Paul, as well as the open space created by the half oval in which the twelve are seated indicate the new, inner space where the Spirit dwells. Jesus is no longer with his disciples. He is risen. But his absence is not an emptiness. On the contrary, his departure has created the space in which his followers can receive the fullness of the Spirit. Jesus himself had prepared them by saying,

> "It is for your own good
> that I am going,
> because unless I go
> the Paraclete [the Spirit] will not

> come to you;
> but if I do go,
> I will send him to you. . . .
> He will lead you to the
> complete truth."
> (Jn 16:7, 13)

With these words Jesus points forward to the new life in the Spirit that will be revealed at Pentecost. It will be a life lived in "complete truth." Closely related to the word "betrothal," the "complete truth" means full intimacy with God, a betrothal in which the complete divine life is given to us.

The twelve rays visible at the top of the icon symbolize the fullness of the Spirit which the disciples have received. The time of confusion, misunderstanding, unbelief, and fear is over. God is no longer an outsider, an unpredictable guide, or an enigmatic stranger. God is the Spirit of the risen Christ who lives within his disciples and fills them with new hope, courage, and confidence. It is this Spirit who makes them say

"Jesus is Lord" (1 Cor 12:3), and cry out "Abba, Father" (Gal 4:7). It is this Spirit who gives them words to speak in front of magistrates and authorities (Lk 12:12), offers them wisdom (Acts 6:10), and guides their decisions (Acts 15:18). It is this Spirit who empowers them to continue Christ's mission of forgiving sins (Jn 20:23) and of bringing the good news of God's inexhaustible love and mercy to all humanity (Mk 16:20).

The quietude and peacefulness of the Pentecost icon express better than any written text the new life that the Spirit gives. It is a life of divine love, lived in the same Spirit as Christ lived his. Thus Paul could say: "I am alive; yet it is no longer I, but Christ living in me" (Gal 2:20). This Spirit of the crucified and risen Christ makes it possible for us to live in the world as he did, without belonging to it.

THE COMMUNITY OF FAITH

The Spirit within, the Spirit of the God of love, the Spirit of the living Christ is the Holy Spirit who creates a new community among those who believe.

This is the second aspect of the spiritual life expressed by the iconographer I am very moved by what this Pentecost icon tells us about community. We live in a time of great loneliness, and therefore we tend to think of community as a place where we can be vulnerable, where we can reveal ourselves fully, come to know others deeply, and develop lasting, intimate relationships. How much do we long for such a community! It is an ideal, very alive in our dreams but very elusive in the daily reality of our lives.

"The Descent of the Holy Spirit," while not denying the importance of interpersonal relationships, portrays community in quite a different light. It reminds us that community is first and foremost a gift of the Holy Spirit, not built upon

mutual compatibility, shared affection, or common interests, but upon having received the same divine breath, having been given a heart set aflame by the same divine fire and having been embraced by the same divine love. It is the God-within who brings us into communion with each other and makes us one. This message both confronts and consoles us. It confronts us with our inability to heal our own brokenness with self-made solutions, and it consoles us with the revelation that God indeed does want to create among us the unity we most long for.

The twelve disciples portrayed in the icon form a perfectly harmonious community. Their unity is graphically reinforced by the use of inverse perspective, which makes the figures grow taller as our eyes move toward the background, and by the golden haloes surrounding the disciples' heads. They truly form one body united by one Spirit. But they are not looking at each other, talking to each other, or working with each other. They are listening together to

the God-within. It is not their common psychological make-up that unites them. How different they are! On the left we see Peter, Matthew, Luke, Andrew, Bartholomew, and Thomas. On the right we see Paul, John, Mark, Simon, James, and Philip. The gospel stories make it clear that these men have not come together because of the compatibility of their personalities. What binds them together in unity are the rays of the divine Spirit descending on them from above. This Spirit has opened their hearts to understand the word they have received from Jesus. This explains why Paul and the four evangelists have books in their hands and all the others have scrolls. The word of God, given to them as a common gift and received by them as a common task, binds them together in a holy community of faith.

Here the mystery of the church is revealed. What this icon shows so convincingly is that the church is unity in diversity. A careful look at the twelve shows that each member of this

community is a unique person. The iconographer has painstakingly given each apostle and evangelist an unrepeatable individuality. Their hair, their eyes, the movements of their heads, their gestures, and the ways they cross their legs and feet are so different that it is quite easy to remember each individual figure. These graphic differences are strikingly reinforced by the use of a variety of deep, full colors. The environment in which they sit is painted with modest yellow-brown tones, but look at the vermillion reds, the deep greens, the yellows, purples, browns, and grays of their mantles and tunics! Still, while each garment is different, together they display a beautiful harmony. No color dominates another, though the red of John, the yellow of Peter and the greens of Andrew, Simon, and Philip form remarkable contrasts.

It is a joy to spend time with each of the twelve. Each has his own way of telling the story. Paul sits up straight and seems quite severe and intellectual. Peter bends over somewhat and

looks more willing to listen. John inclines his head and offers affection, while Matthew and Mark are eager to explain everything with their outstretched arms. Philip, sitting cross-legged in the right corner, might be willing to engage in a more informal chat, and Thomas on the left looks so young that you wonder how *he* will express his experience with Jesus. They all have their own way of living and speaking the good news that has entered deeply into their hearts.

The closer I come the more differences I see, but every time I take a few steps back I realize again that they belong to one community, that they form one body, and are bound together by the Spirit of their one and only Lord, Jesus Christ.

LIBERATING THE WORLD

The community of faith fashioned by the God-within, the Holy Spirit, is not fashioned

simply for the well-being of its members but for the liberation of the world. This is the third aspect of the spiritual life made visible in the icon of the Descent of the Holy Spirit. The icon reminds us in a forceful way that the Spirit of Christ who has called us together into one body sends us into the world so that all people can share in the fruits of the redemption accomplished through the death and resurrection of Jesus.

The king-like figure standing in the darkened gate at the bottom of this Pentecost scene speaks of the world's need for liberation. This figure is essential for understanding the descent of the Spirit. When I first saw the icon, I felt disturbed by this puzzling, rigid person with an unnatural-looking crown, a dull face, a drab vestment, and a long white cloth stretched over his outstretched arms. In contrast to the lively figures of the apostles and evangelists, this man looked to me like a lifeless puppet. And why this strange, oval-shaped door that looks out

upon nothing but utter darkness? I felt that the elegant Pentecost scene portrayed was violated by this ugly "scene" there at the bottom. Why was the open space formed by the disciples not kept completely open? It would have been so much more harmonious and peaceful.

As I started to read various commentaries on the icon, especially those by Paul P. Muratov, Leonid Ouspensky, and Daniel Rousseau, I gradually realized that my romantic desires were far from the intentions of the iconographer. The stiff king in the dark gate needs to be there. Pentecost is not the beautiful end of the salvation story, but the beginning of a mission to go out into the world, make disciples of all nations, baptize them in the name of the Father, the Son, and the Holy Spirit, and teach them to observe all the commands that Jesus gave us (see Matthew 28:19–20). The same Spirit who binds the disciples of Jesus together into a vibrant community of faith, sends them into the world to

liberate those who dwell in "darkness and the shadow of death" (Lk 1:79).

In the oldest Pentecost icons, the multitudes who came from all directions at the sound of the Spirit (see Acts 2:5) were portrayed at the bottom of the icon. But later icon painters, in order to maintain the solemn quietude of the whole composition, replaced the crowd with one symbolic figure. This figure often wears the inscription: "Cosmos." This Cosmos, an older somber man, represents all the peoples living in darkness to whom the light of the apostles' teaching has been brought.

When I read this interpretation, the icon assumed a new dimension for me. It became not just an icon of great inner peace and harmony, but also an icon with a call. An urgent appeal to action has been added. Many live in darkness and wait for the light of the word of God. Now I can see clearly that Cosmos carries in the white linen cloth the twelve scrolls on which the divine word preached by the twelve has

been written. Their white color contrasts markedly with the darkness in which Cosmos finds himself. The light of God's word needs to be brought to the captive world. Thus, this restful Pentecost scene becomes a profound call to liberation. The scrolls and books placed in the hands of the twelve are not to be kept there for their own enlightenment, but are to be placed into the hands of people from all times and places so that they too can participate in the new life that the Spirit brings.

As I call to mind the materialism and hedonism of my own country, the poverty in Asia, Africa, and Latin America, and the violence in Lebanon, Ireland, Central America, and many other places; and as I think about the prisoners and handicapped people behind the bars of large, impersonal institutions, the sick who receive little or no care, the young who lack opportunities for education or decent work, the dying who remain alone in their last hours, and all who are lonely or afraid—then the rigid

puppet king in the darkened door takes on ominous dimensions and becomes the representative of humanity, caught in a worldwide network of individual and social sin. The dark cave at the bottom of the icon cannot be ignored. It speaks about the bitter strife on our planet, a planet whose existence is increasingly endangered by destructive powers invented and accumulated by an "enlightened" humanity. That somber old ruler needs to remain there to ensure that the descent of the Holy Spirit is never sentimentalized, but always remains a descent into a world yearning for liberation.

Who can take on this task of liberation? If we try to respond to the crying needs of the world as individuals we will soon find ourselves surrounded by "powers and principalities" far beyond our understanding or control. Then despair surely awaits us. But "The Descent of the Holy Spirit" reveals that a community fashioned by God can indeed become involved in the struggle for justice and peace without being

destroyed by it. Although this community consists of fragile human beings with very limited abilities, it is the Spirit of God who gives it its liberating power. Thus, this icon both offers hope for the liberation of the world and encourages us to work for it.

CONCLUSION

"The Descent of the Holy Spirit," as portrayed by the Russian iconographer at the end of the fifteenth century, shows a new community of faith formed by the Spirit of God who dwells in our hearts and who commissions us to liberate our captive world. The icon brings together prayer and ministry, contemplation and action, quiet growth in the Spirit and mission to our restless world. It proclaims that the community of faith is a safe place to dwell, but also a center from which a call goes forth to liberate the world.

Leonid Ouspensky tells us that two icons are especially venerated in Russian churches on the day of Pentecost: the icon of the Descent of the Holy Spirit and the icon of the Holy Trinity.[12] Thus, the intimate connection between the birth of the community of faith and the mystery of the Triune God is expressed. Indeed, the harmonious circle in which the disciples are seated is a reflection of the harmony among the three divine persons, most beautifully portrayed by Andrew Rublev in his icon of the Holy Trinity. Russian iconography helps us see how the mystery of the church and the mystery of the revelation of the inner life of God can never be separated. Both God—Father, Son, and Holy Spirit—and the church, the community where life is lived in the name of the Triune God, belong to the Apostles' Creed. If we keep this inner connection before our minds and hearts, we will avoid treating the church as just a human organization that may or may not help us in our spiritual lives. The connection between the

mystery of God and the mystery of the church is beautifully expressed by Archbishop Anthony when he writes:

> Thus, according to the likeness of the Holy Trinity, undivided and distinct, there is formed a new being, the holy church, one in its being, but multiple in persons, whose head is Christ and whose members are angels, prophets, apostles, martyrs, and all those who have repented in faith.[13]

This Trinitarian vision of the church helps us comprehend the full meaning of brotherly and sisterly love. Jesus had already told his disciples that his love for them was as full as the love of his Father for him, and that their love for each other should be as full as the love of Jesus for them.

> "I have loved you
> just as the Father has loved me . . .

Love one another
as I have loved you."
(Jn 15:9, 12)

At Pentecost he sends them the Holy Spirit, the spirit of love with which the Father and Son love each other, thus creating a community according to the likeness of the divine life. Just as Adam and Eve were created in the image of God, so the church was created in the image of the triune life of God revealed by Jesus the Christ. Therefore, it is significant that Jesus' words, "Love one another as I have loved you" are directed to his most intimate friends, his disciples. Those who know Jesus are called to manifest his love in their common life, and thus become a sign of hope in the midst of a fearful world.

"The Descent of the Spirit" is a door which leads us into the mystery of God's inner life. When I first saw it, I felt no attraction to it. But when I took the time to be with and pray with the icon, it gradually opened itself to me and

told me the story of our redemption. I hope that all who read this reflection with the icon before them will also become more fully aware of the "unfathomable treasure of Christ," and see more clearly "the inner workings of the mystery kept hidden through all ages in God, the Creator of everything" (Eph 3:8–9).

CONCLUSION

The icons gathered together in this book have been familiar to me for a long time. I have seen many reproductions of them in churches, convents, retreat centers, and homes. But it is only since I started to view them as the iconographer intended—not as decorations but as holy places—that they have told me their secrets. They have told me that we are all called to enter into the loving communion among Father, Son, and Spirit. They have told me that the Virgin Mary, chosen by God to become the Ark of the New Covenant, gently invites us to choose Jesus as the way to fully belong to God. They have told me that Jesus, who sees the depths of God as well as the depths of the human heart, is the full manifestation of God's saving presence among us. Finally, they have told me that through a new community formed by the Spirit Christians are called to make God's love visible, and thus work for the liberation of the world.

While I originally looked at these icons independently of each other, they gradually began to form a unity. Together they portray a movement from the community of God to the community of faith, a movement realized through Jesus, Son of Mary, Son of God. It is not just the individual icons that have stories to tell. Together they also tell a story. They tell us that Jesus, truly human and truly divine, calls us to become part of the inner life of God, not only when we have finished our earthly journey but also now, as we come together in faith. In the sequence of this book, the Holy Trinity becomes a prefiguration of the Pentecost community, and the Pentecost community a reflection of the Holy Trinity. The two are connected by the mysterious Incarnation of the Word of God, expressed in the icons of the Virgin of Vladimir and the Savior of Zvenigorod.

All four icons speak of a God not hidden in the dazzling splendor of the divine light but reaching out to a world yearning for freedom.

In each of these four icons the world is present. The world appears as the open space at the front of the altar of the Holy Trinity. The world appears in the wooden frame in which the Virgin and child are held. The world shows itself in the damaged wooden panel on which all is lost except the compassionate face of the Savior. Finally, the world is made manifest in the rigid king, standing by the dark gate at the edge of the Pentecost scene. God loves the people of the world so much that we were chosen to become the vehicle for God's self-revelation. Sinful men and women made of dust, not pure, immaterial angels, were chosen to share the mystery of God's inner life, expressed in Father, Son, and Spirit. For "it was not the angels that he took to himself; he took to himself descent from Abraham" (Heb 2:16). God did not keep any secrets from us, but in and through the Word spoken from all eternity and clothed with human flesh in the womb of a woman, God made everything known to us. Thus, we have become the

privileged recipients of the mystery that had remained hidden in God for ages. We have become as intimately connected to God as Jesus is. We have truly been made children of God.

These four icons tell us this sacred truth in four different ways. Each of them individually, and all of them together, give us a glimpse of the house of love prepared for us by Jesus and invite us to experience, even now, the joy of living there.

Working on these meditations has been a great delight. Praying became writing and writing became praying. More energy was granted than consumed in the process. I fervently hope that you who read these meditations will experience some of this same delight, and thus deepen your desire to behold the beauty of the Lord expressed in these holy images.

REFERENCES

THE ICON OF THE HOLY TRINITY

1. For this meditation, I have consulted the following studies:

Paul Evdokimov, *L'Art de L'Icône: Théologie de la Beauté*, Paris: Desclée de Brouwer, 1970.

Leonid Ouspensky and Vladimir Lossky, *The Meaning of Icons*, Crestwood, NY: St. Vladimir's Seminary Press, 1983.

THE ICON OF THE VIRGIN OF VLADIMIR

2. In this meditation, I have drawn upon the following studies:

Evdokimov, *L'Art de L'Icône,* especially 217–223: "L'Icône de Notre Dame de Vladimir."

Egon Sendler, *L'Icône, Image de L'Invisible: Elements de Théologie Esthétique et Technique,* Paris: Desclée de Brouwer, 1981.

THE ICON OF·THE SAVIOR OF ZVENIGOROD

3. In this meditation I have used mainly:

V. N. Lazarev, *The Moscow School of Icon Painting*, Moscow: Isskustvo, 1971.

M. Alpatov, *Andrei Rubliov,* Moscow: Izobrazitel'noe Isskustvo, 1972.

4. See "The Russian Renaissance: Andrei Rublyov" (for the 625th anniversary of his birth), *Soviet Life,* Oct. 1985, 55.

5. Alpatov, *Andrei Rubliov,* 74.

6. Lazarev, *The Moscow School of Icon Painting,* 21.

7. Lazarev, *The Moscow School of Icon Painting,* 21.

8. Alpatov, *Andrei Rubliov,* 74.

9. Lazarev, *The Moscow School of Icon Painting,* 22.

10. Alpatov, *Andrei Rubliov,* 73.

THE ICON OF THE DESCENT OF THE HOLY SPIRIT

11. In this meditation I have used the following studies:

Paul Muratoff, *Trente-cinq Primitifs Russes, Collection Jacques Zolonitsky, à la Vieille Russie,* Paris: 18 Faubourg Saint-Honoré, 1931.

Ouspensky and Lossky, *The Meaning of Icons.*

Daniel Rousseau, *L'Icône, Splendeur de Ton Visage,* Paris: Théophanie, Desclée de Brouwer, 1982.

12. Ouspensky and Lossky, *The Meaning of Icons,* 208.

13. Archbishop Anthony, *Collected Works,* vol.11, 75–76, quoted in Ouspensky and Lossky, *op. cit.,* 208.

Henri J.M. Nouwen is one of the most popular spiritual writers of our time. He wrote more than forty books, among them bestsellers *With Open Hands* and *Out of Solitude*. He taught at Yale University, Harvard University, and the University of Notre Dame. From 1986 until his death in 1996, he taught and ministered to physically and mentally challenged men and women as a member of the L'Arche Daybreak community in Toronto, Canada. Learn more about Nouwen's life and works at www.henrinouwen.org.

More than One Million Copies Sold!
The Henri J.M. Nouwen Collection

Eternal Seasons
*A Spiritual Journey
through the Church's Year*
Edited by Michael Ford
ISBN: 9781594711473
256 pages / $12.95

Heart Speaks to Heart
*Three Gospel Meditations
on Jesus*
Foreword by Christopher de Vinck
ISBN: 9781594711169
64 pages / $7.95

Can You Drink the Cup?
Foreword by Ron Hansen
ISBN: 9781594710995
128 pages / $10.95

The Dance of Life
*Weaving Sorrows and
Blessings into One Joyful Step*
Edited by Michael Ford
ISBN: 9781594710872
224 pages / $12.95

With Open Hands
Foreword by Sue Monk Kidd
ISBN: 9781594710643
128 pages / $9.95

Out of Solitude
*Three Meditations
on the Christian Life*
Foreword by Thomas Moore
ISBN: 9780877934950
64 pages / $7.95

In Memoriam
Foreword by Michael O'Laughlin
ISBN: 9781594710544
64 pages / $7.95

Available from your bookstore or from
ave maria press / Notre Dame, IN 46556
www.avemariapress.com / Ph: 800-282-1865
A Ministry of the Indiana Province of Holy Cross

Keycode: FØAØ8Ø7ØØØØ